Puppies, Puppies Everywhere!

Puppies, Puppies Everywhere!

Written by
Peggy Schaefer

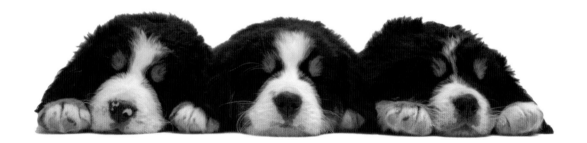

Ideals Publications Nashville, Tennessee

ISBN 0-8249-5887-X

Published by Ideals Publications
A division of Guideposts
535 Metroplex Drive, Suite 250
Nashville, Tennessee 37211
www.idealsbooks.com

Color separations by Precision Color Graphics, Franklin, Wisconsin

Printed and bound in Italy by LEGO

Designed by Marisa Calvin

Front jacket photograph: Noriyuki Yoshida/SuperStock
Back jacket photograph: Stock Connection Distribution/Alamy
Jacket flap photograph: age fotostock/SuperStock

1 3 5 7 9 10 8 6 4 2

Whoever said you
can't buy happiness
forgot about
little puppies.
—Gene Hill

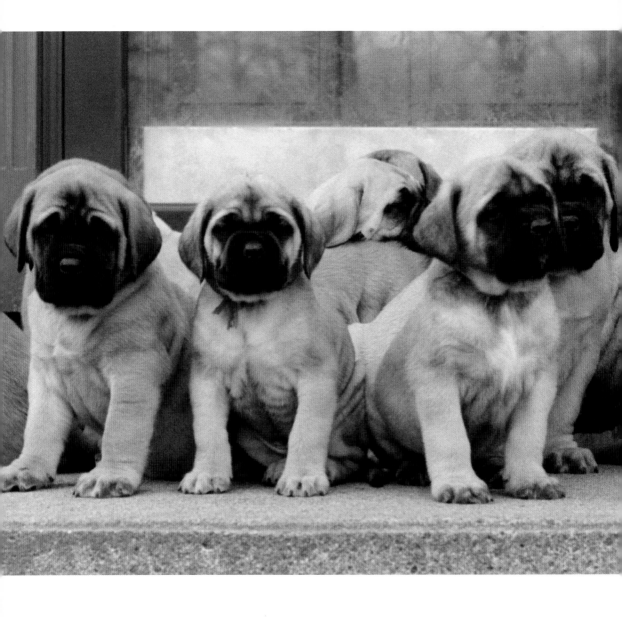

Puppies, puppies everywhere,

sometimes
one,

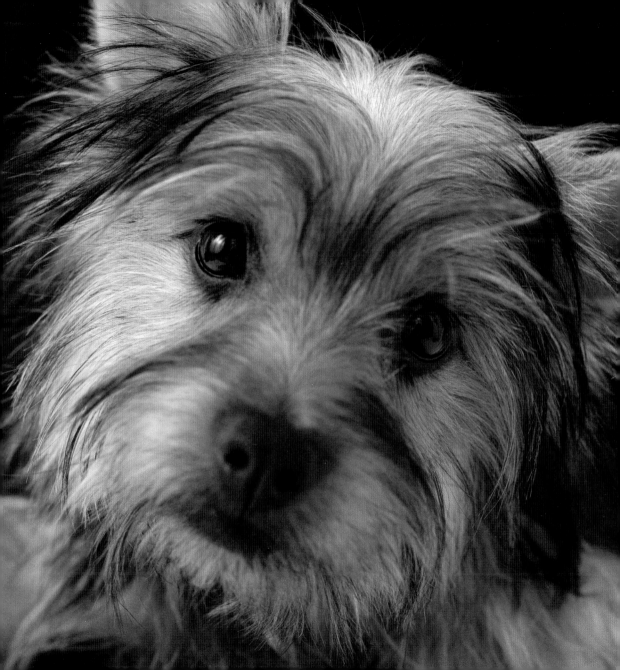

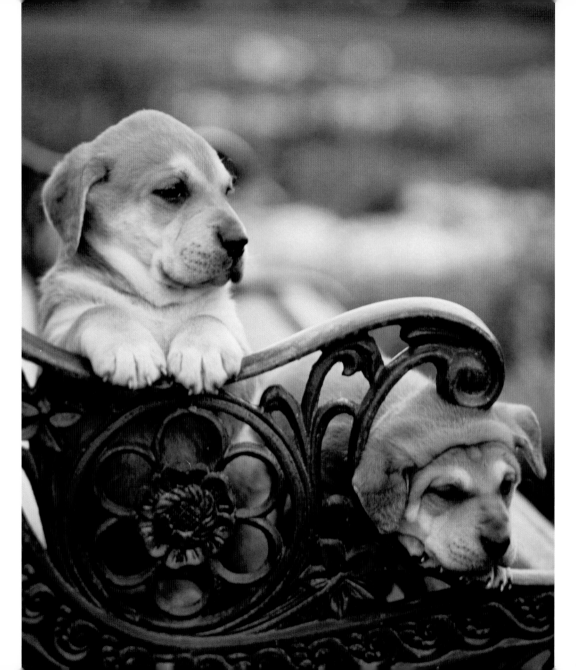

sometimes
a pair.

Maybe 3...

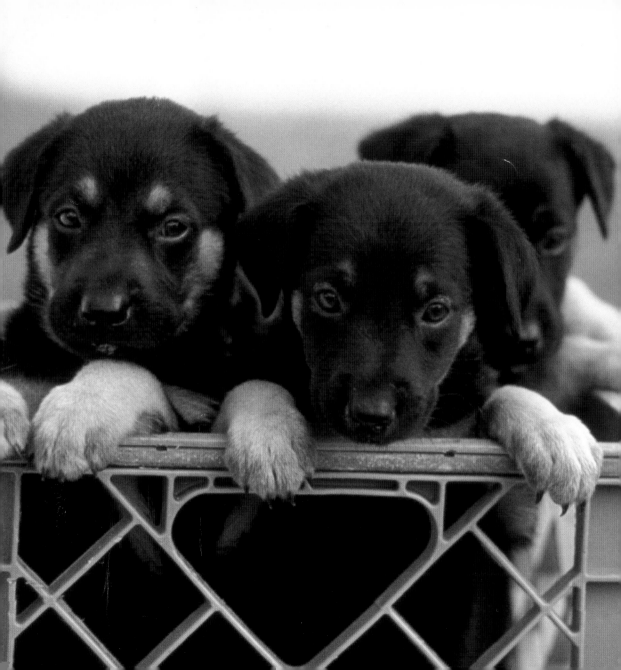

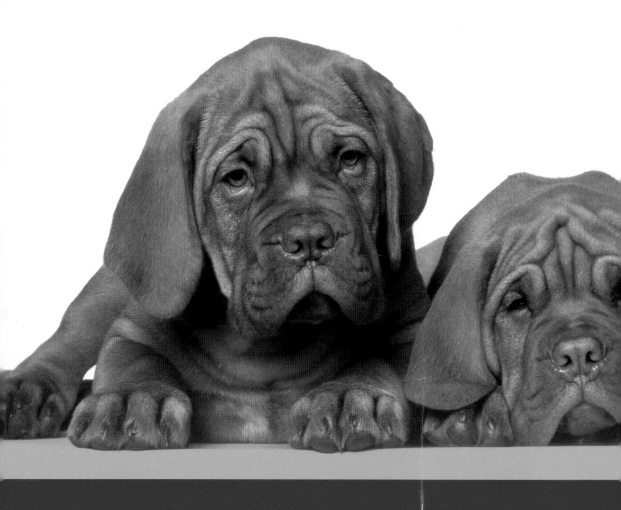

could there

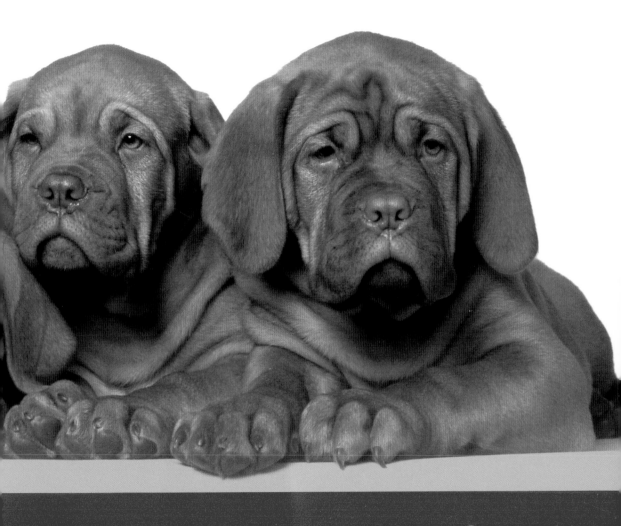

be four?

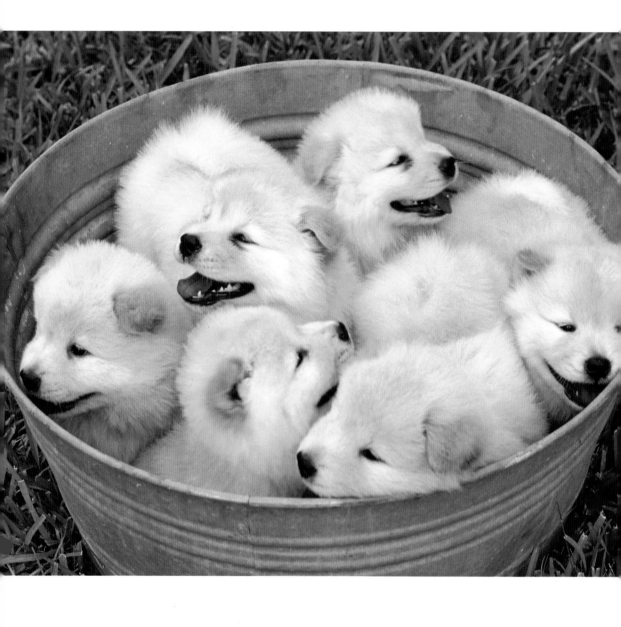

Sometimes many, **many** more!

BLACk

pup,

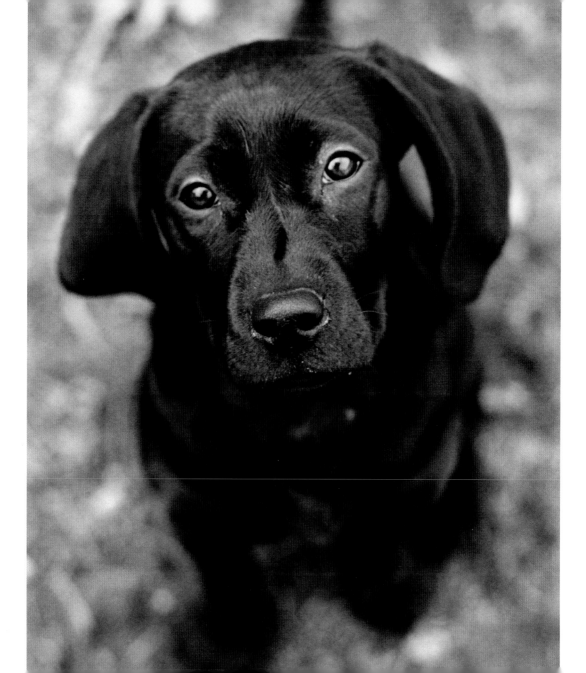

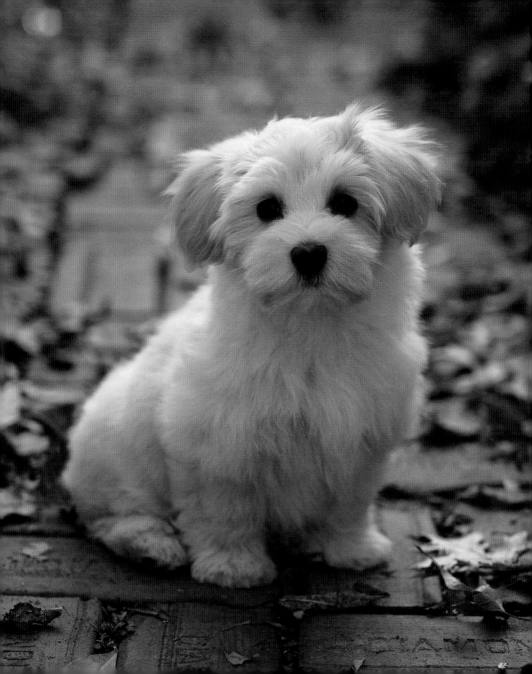

WHITE

pup,

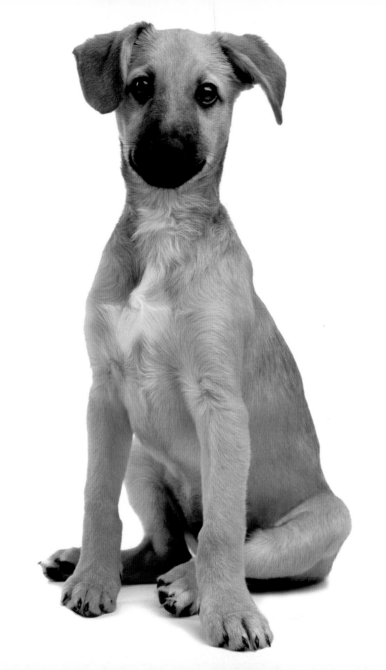

big pup,

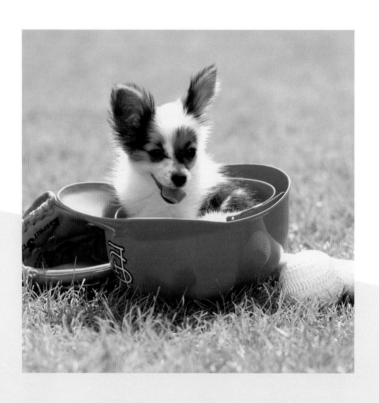

small.

Labrador retriever

Chow

Greyhound

Poodle

Dachshund

Great Dane

Boxer

Collie

Weimaraner

Basset hound

Golden retriever

Pug

We don't care—
we like them all.

German shepherd

Siberian husky

Yorkshire terrier

Border collie

Alaskan malamute

Lhasa apso

Newfoundland

Shetland sheepdog

Great Pyrenees

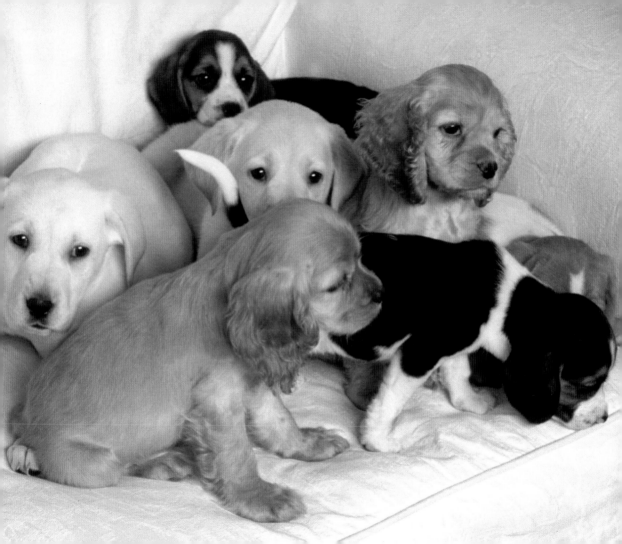

PUREBRED,

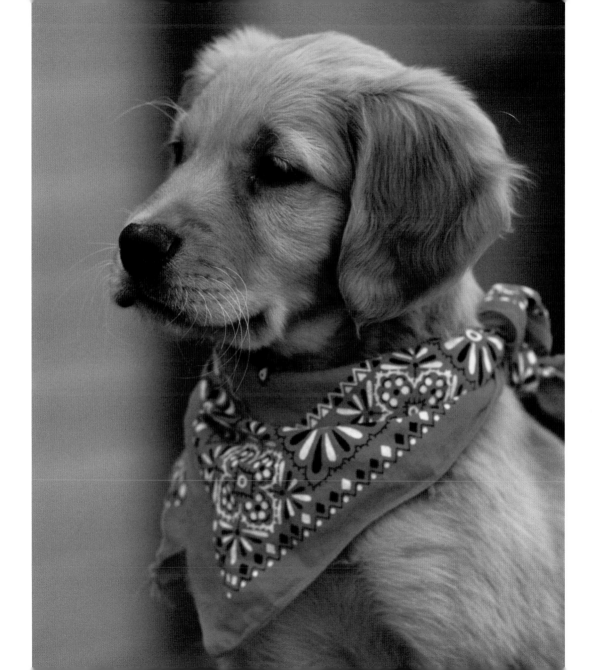

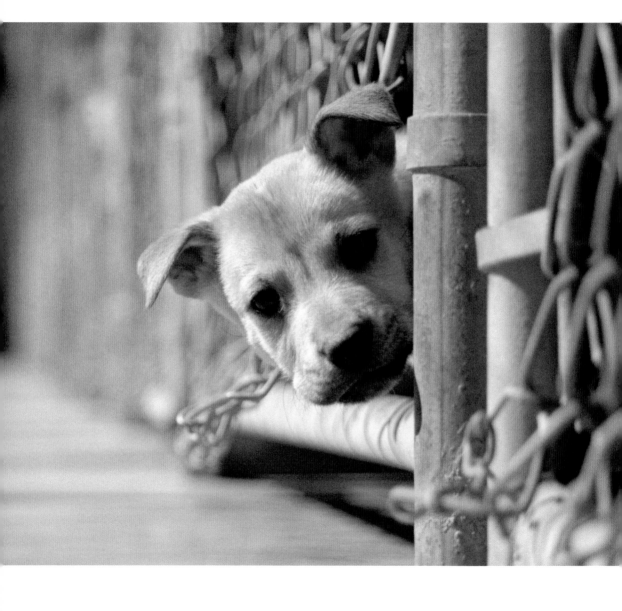

POUND PUP,

doesn't matter—

little
puppies
like to
splatter.

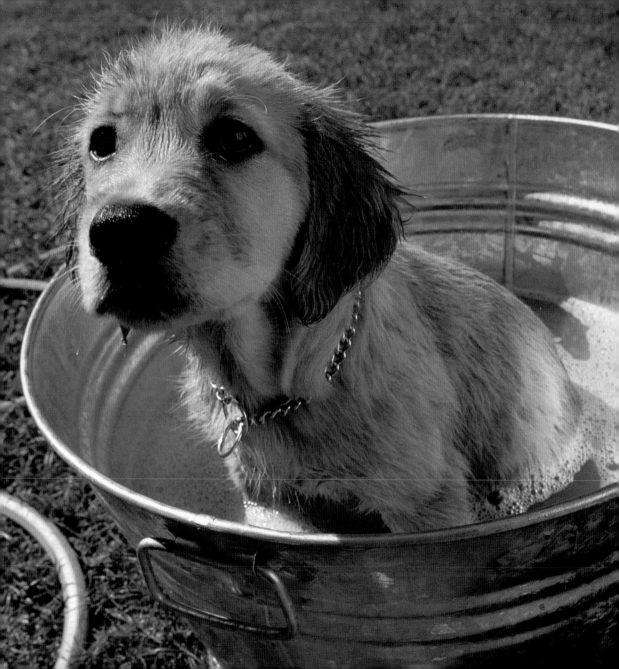

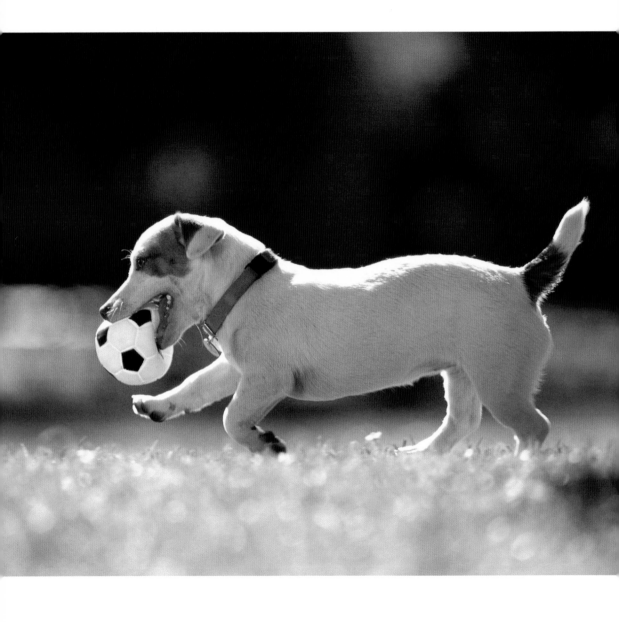

Jingling
trot
across the lawn—

naptime now, after a yawn.

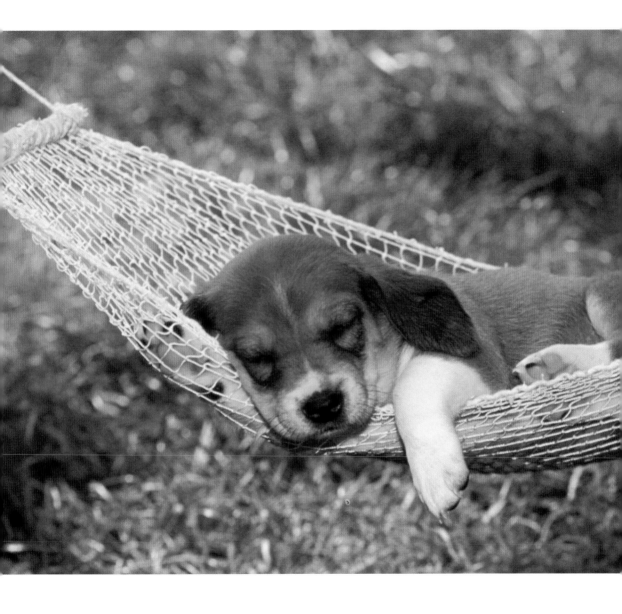

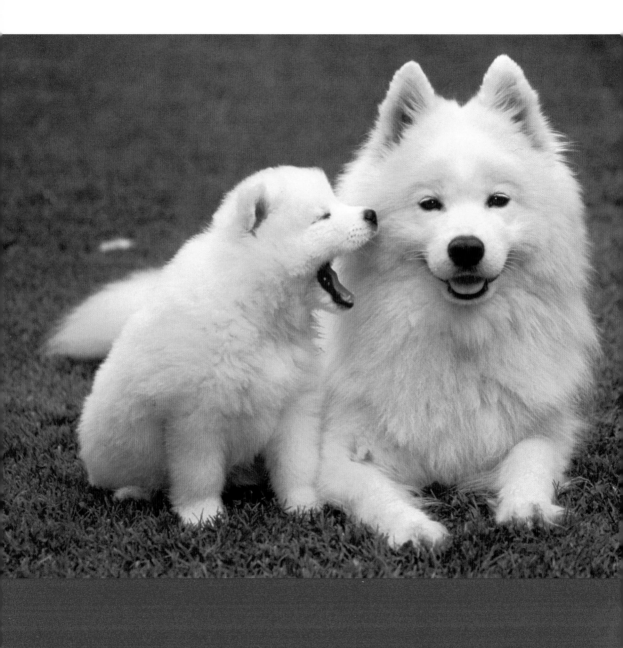

Yipping, yap-yap yip yap

yapping,

sometimes SNAPPING,

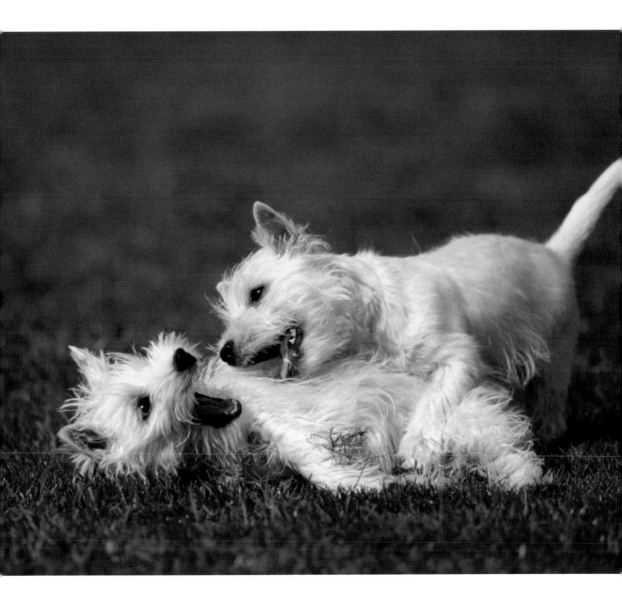

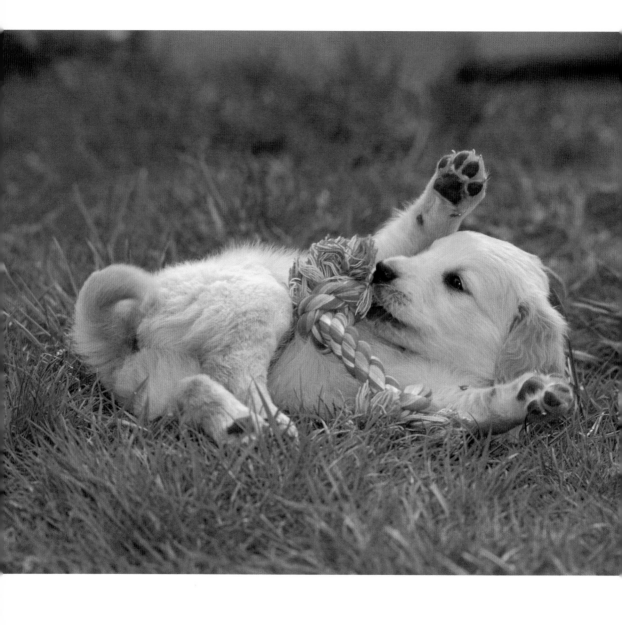

little puppies

having fun.

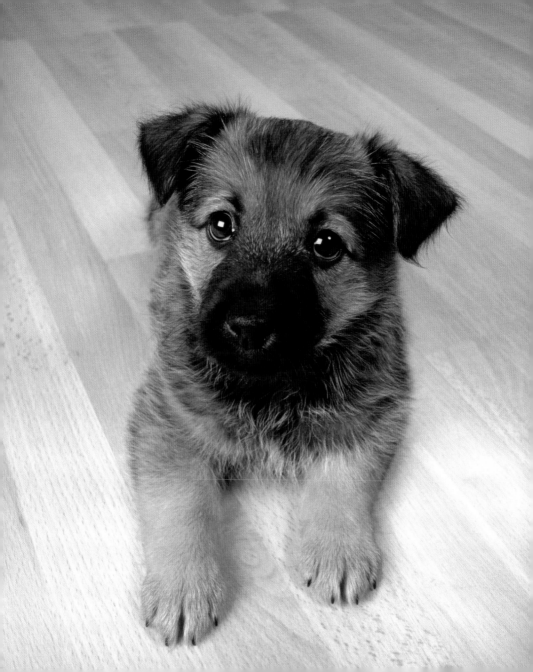

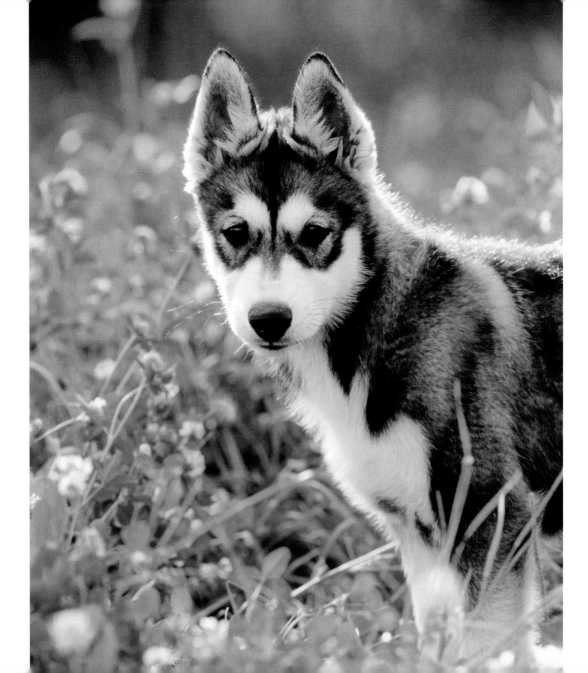

outside,

all around,

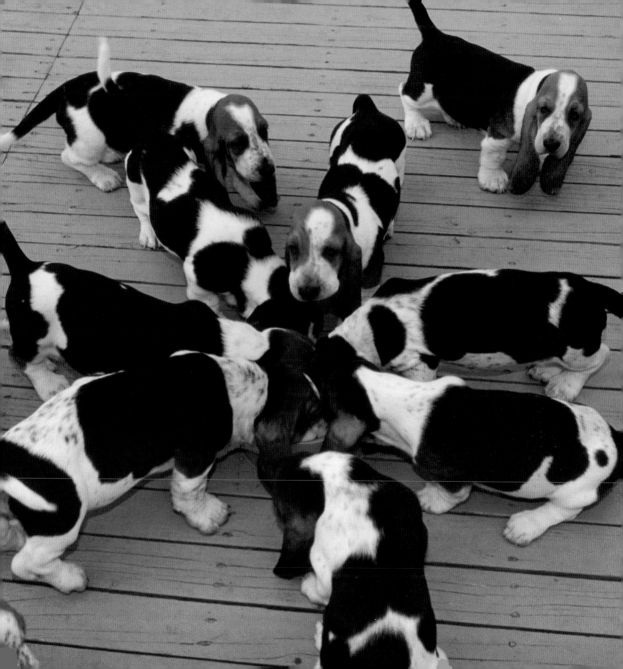

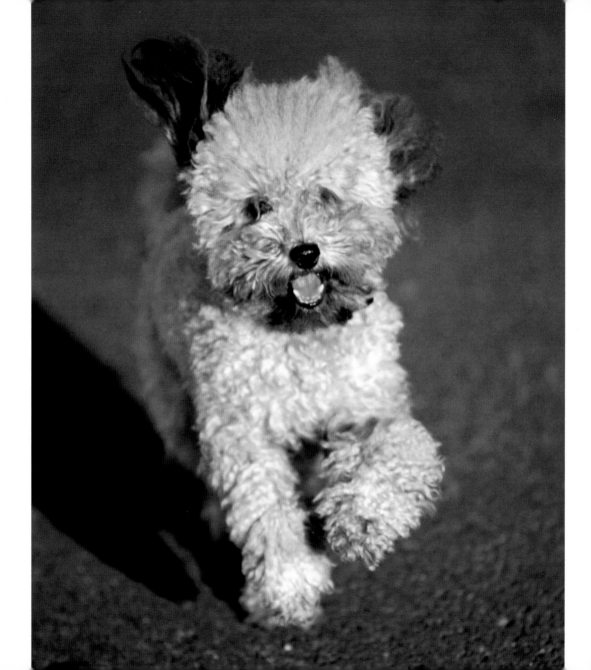

puppies
cover lots
of ground.

Chewing,

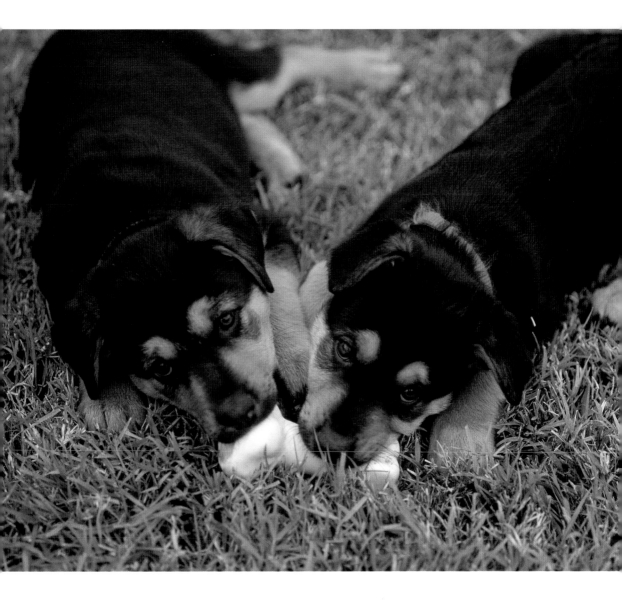

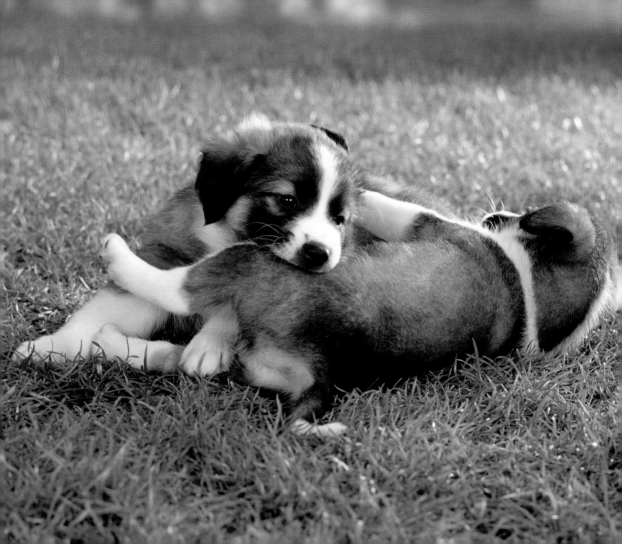

wrestling,

digging holes,

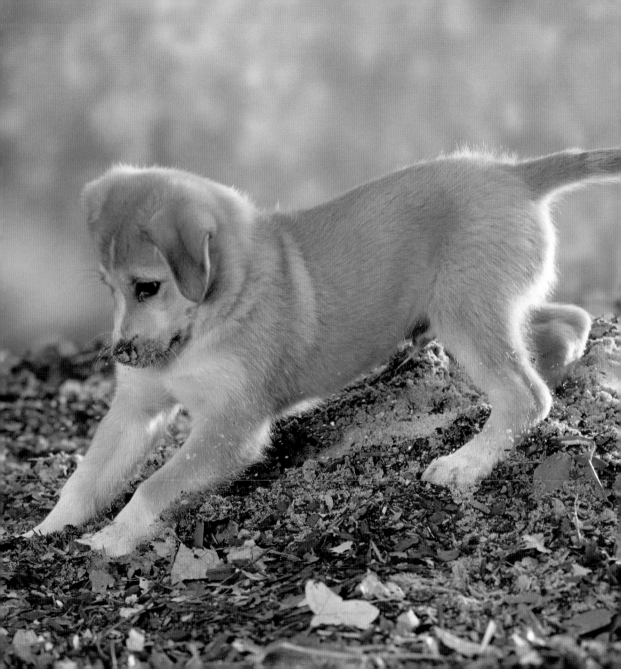

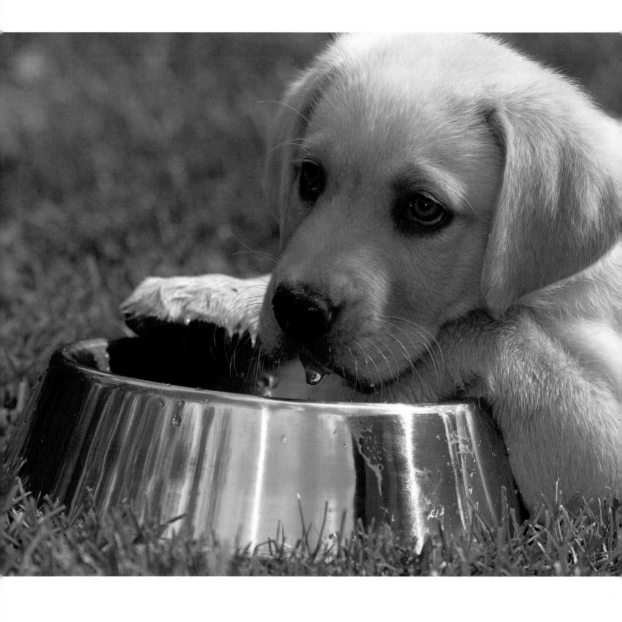

playing
in their water bowls.

Start to leave and they will POUT

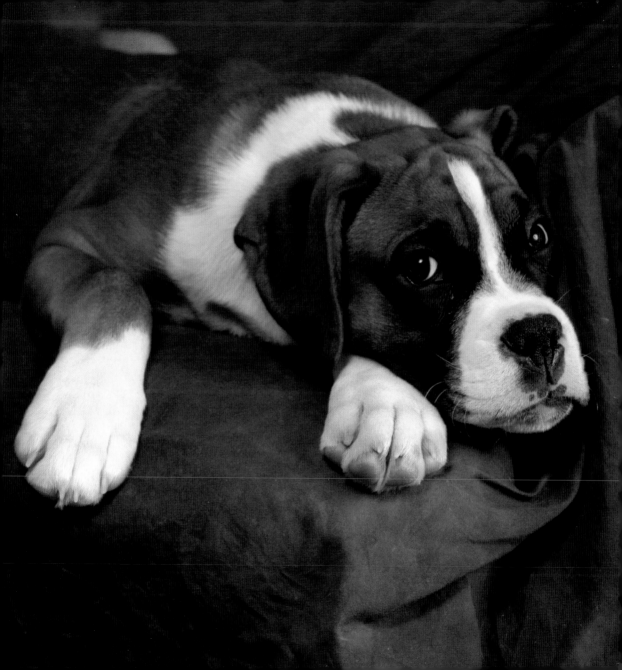

then on
the bed once
you are out!

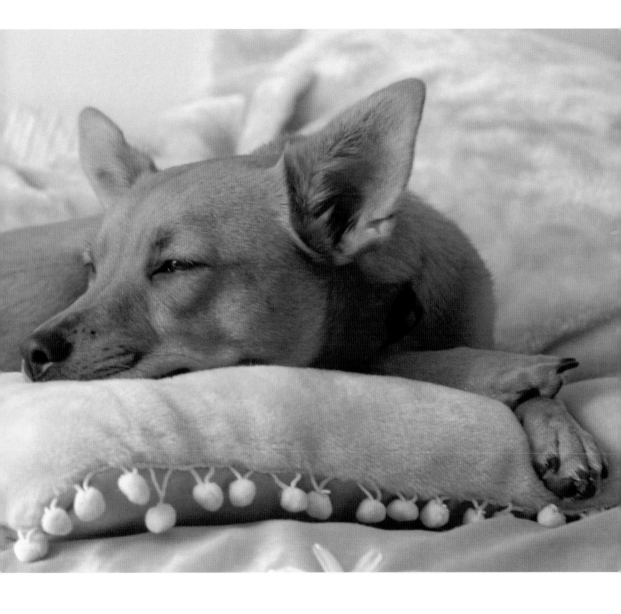

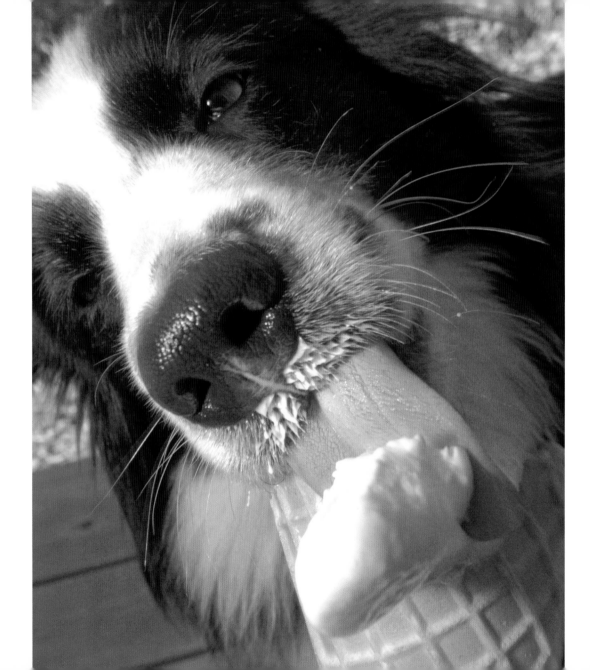

Some pups lick.

Some

pups

BARK,

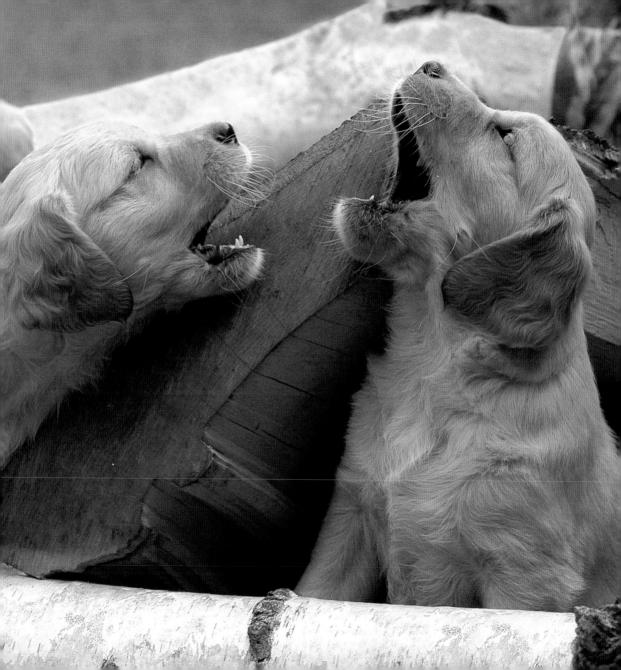

some tear everything apart.

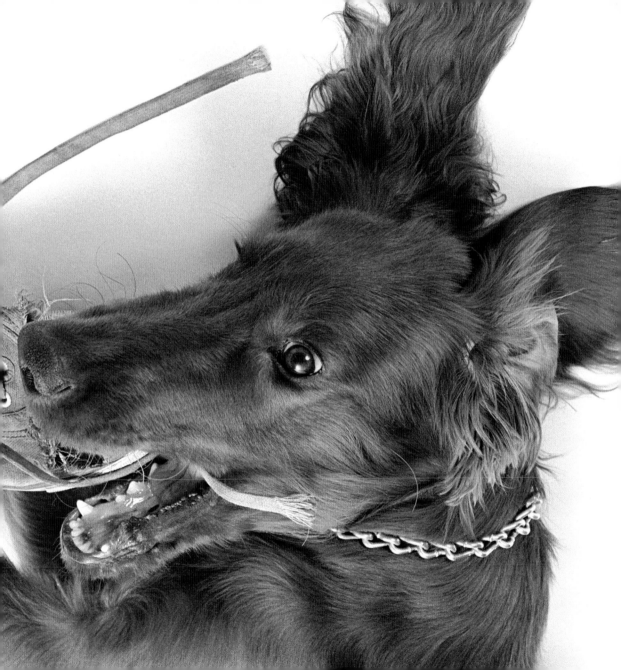

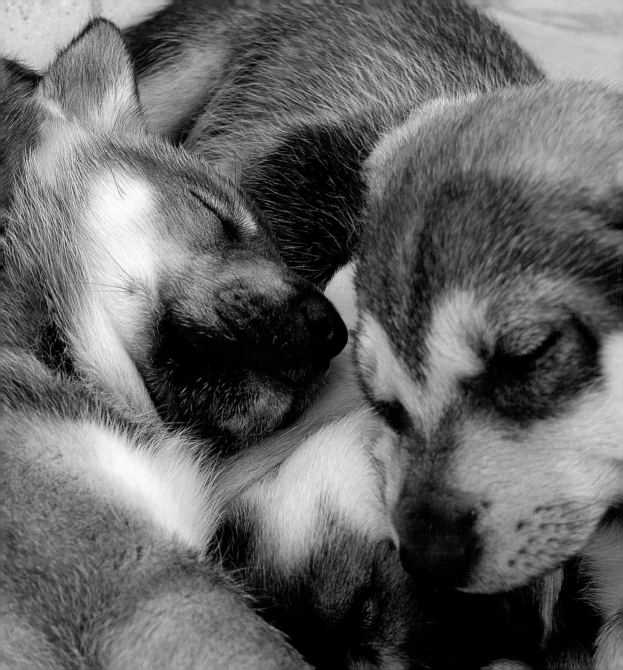

Puppies,
puppies
everywhere—

some of
every kind.

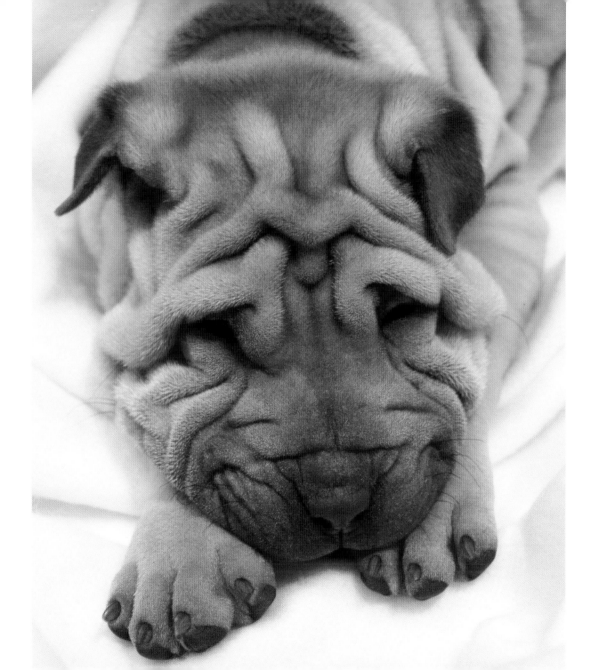

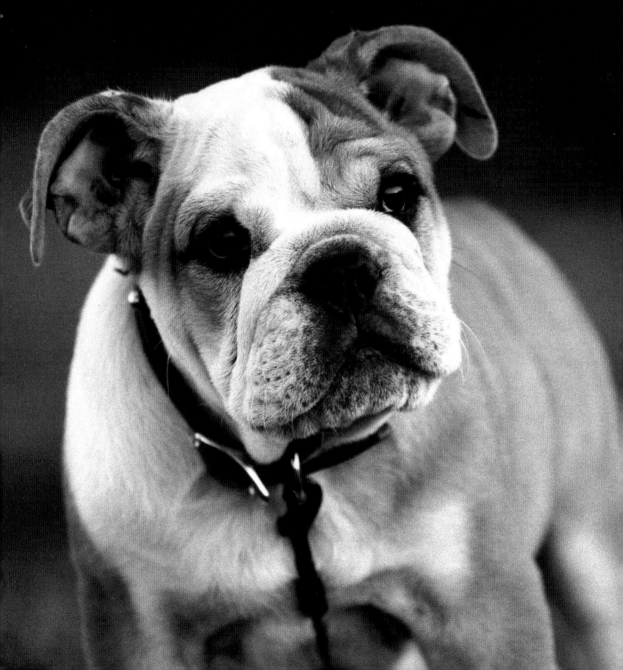

BIG

AND
TOUGH,

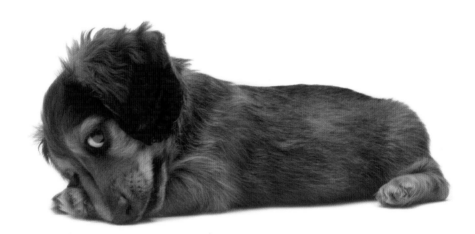

small and shy—

we
like
our
pups
just
fine.

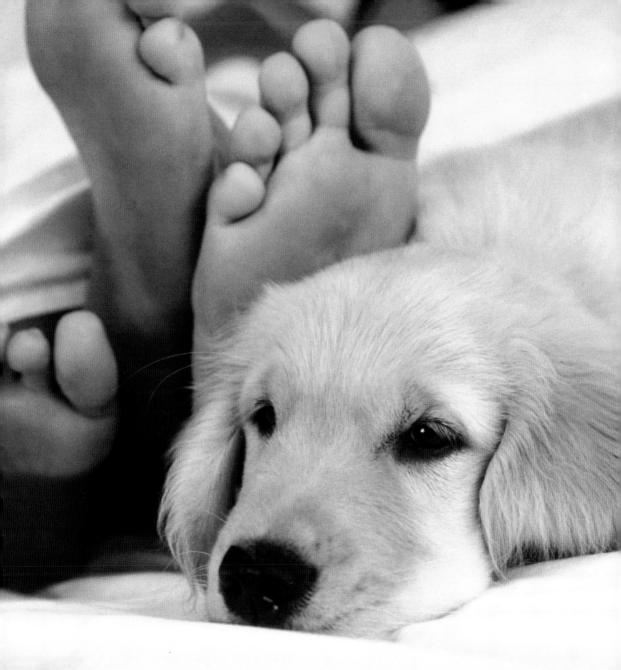